Beautiful Mandalas

COLORING BOOK FOR ADULTS

Coloring Therapists

STRESS RELIEVING COLORING ACTIVITIES

Coloring Therapists LLC
40 E. Main St. #1156
Newark, DE 19711
www.coloringtherapists.com

Copyright 2016

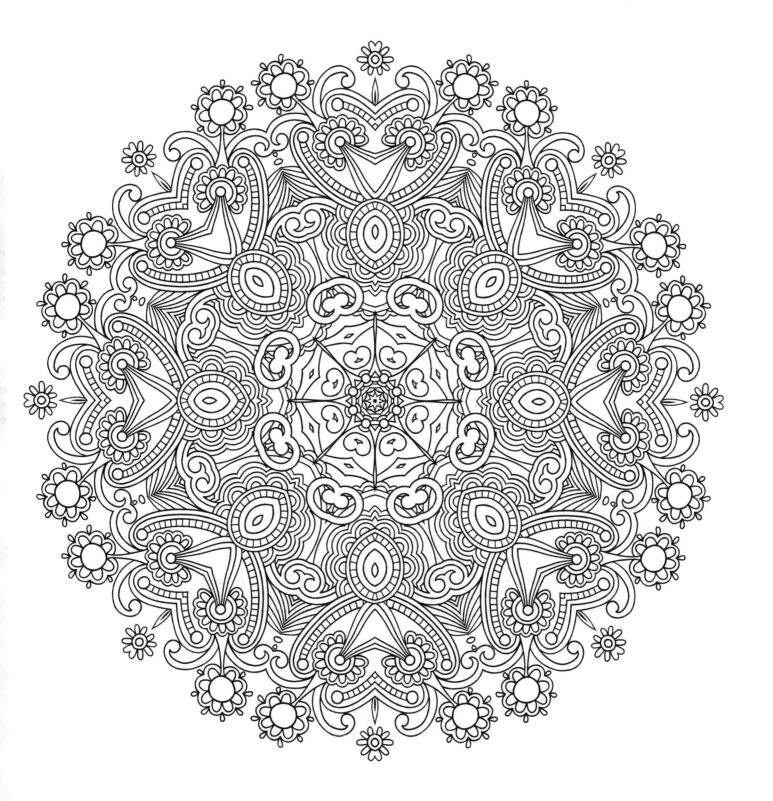

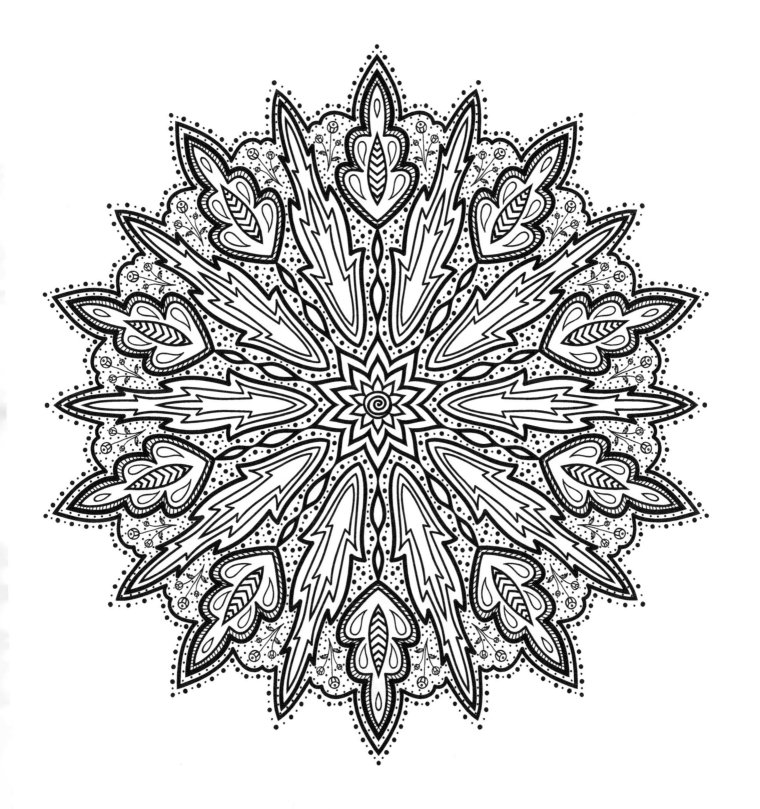

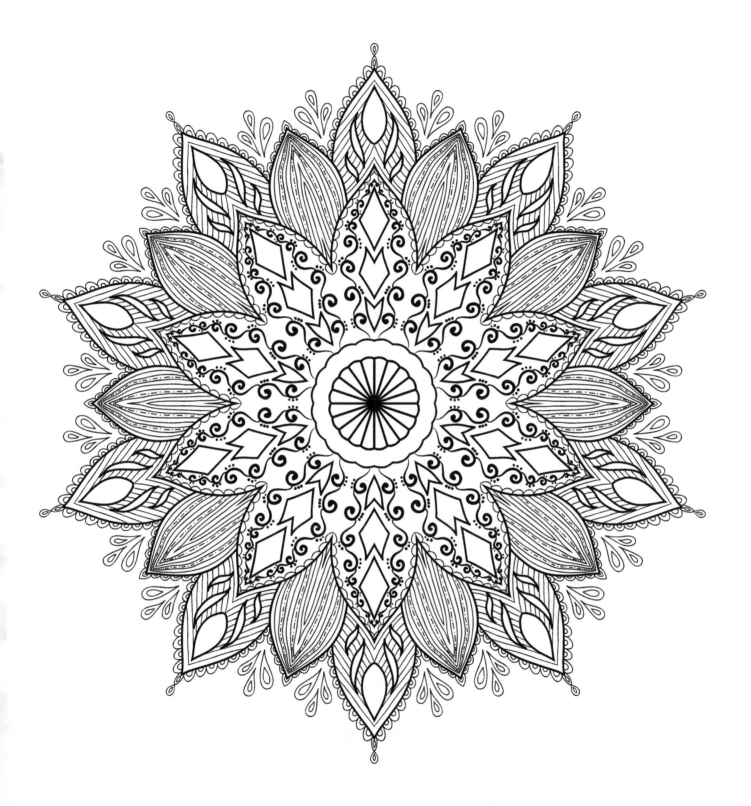

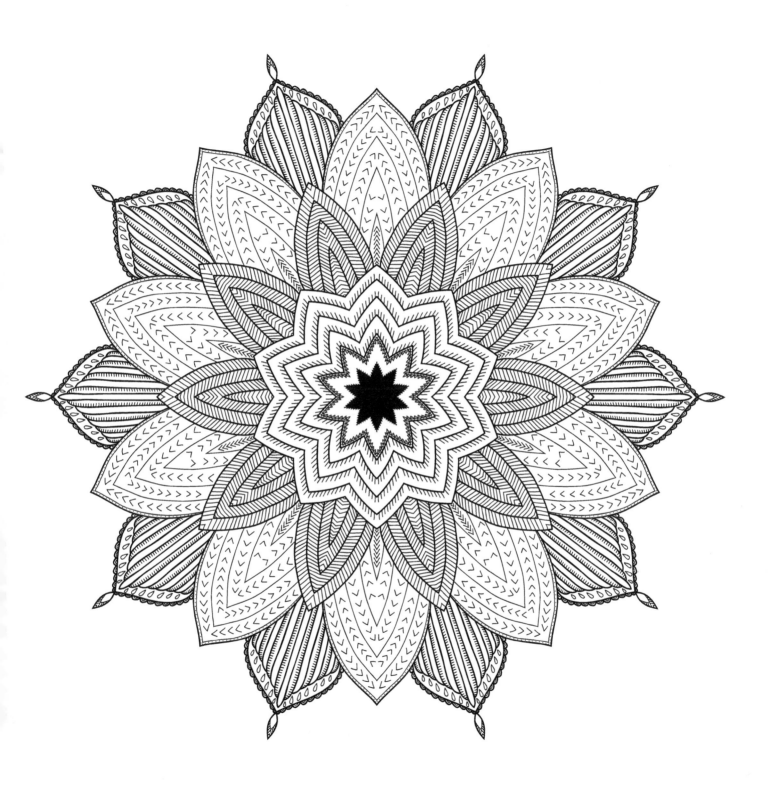

This is a Bleed Through Page If You Are Using a Coloring Marker or Pen!
Find Other Great Titles By searching for Coloring Therapists on Your Favorite Book Retailer
Amazon.Com | Barnes & Noble (BN.Com) | Books A Million (BAM.Com)

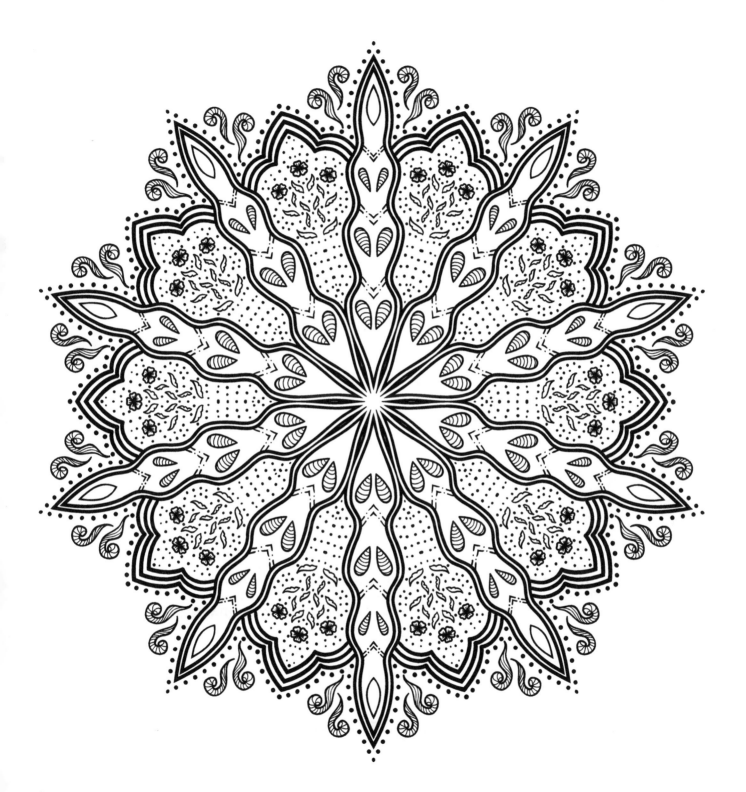

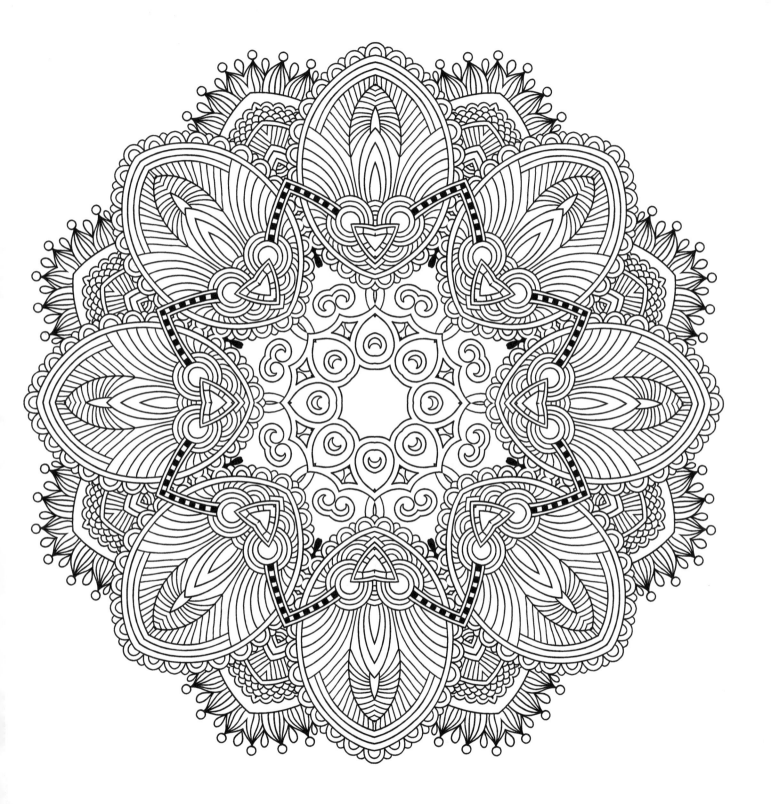

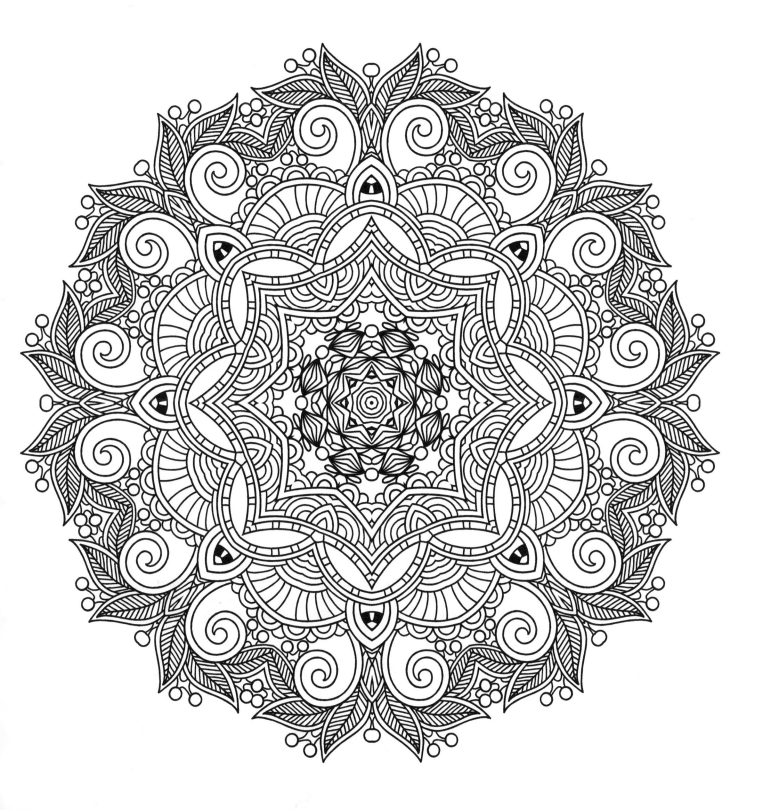

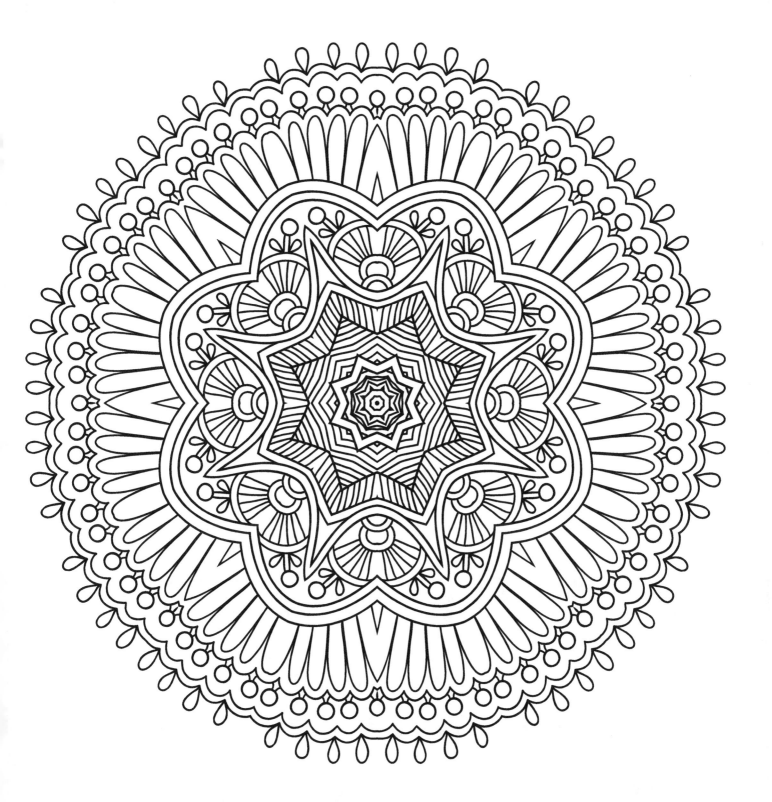

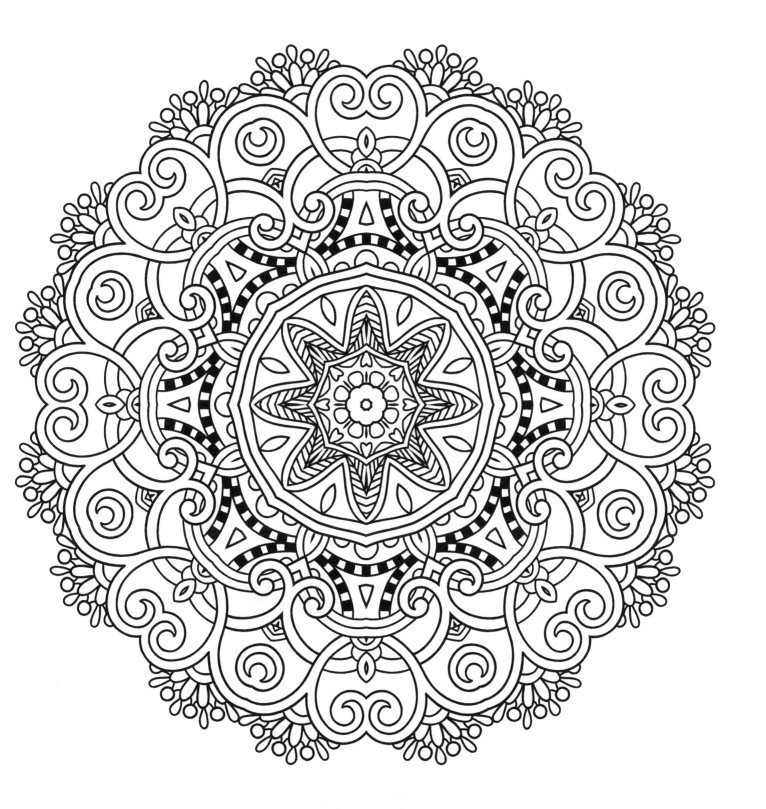

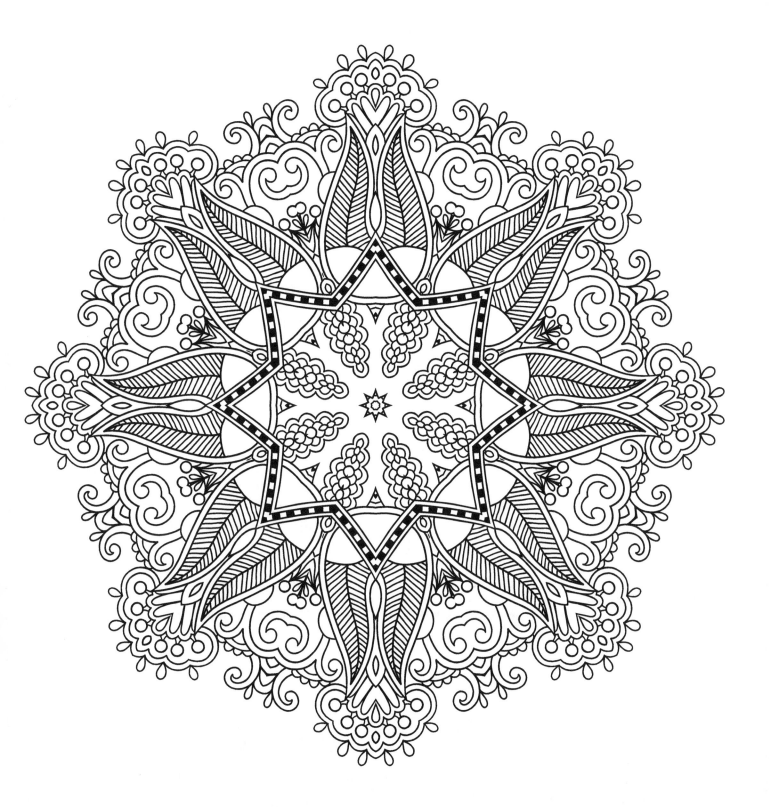

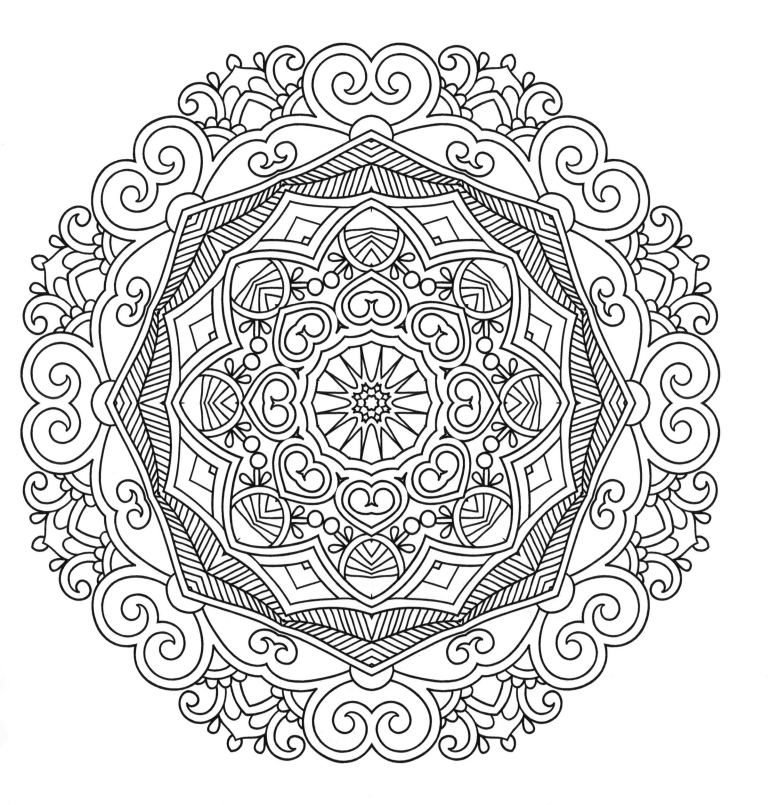

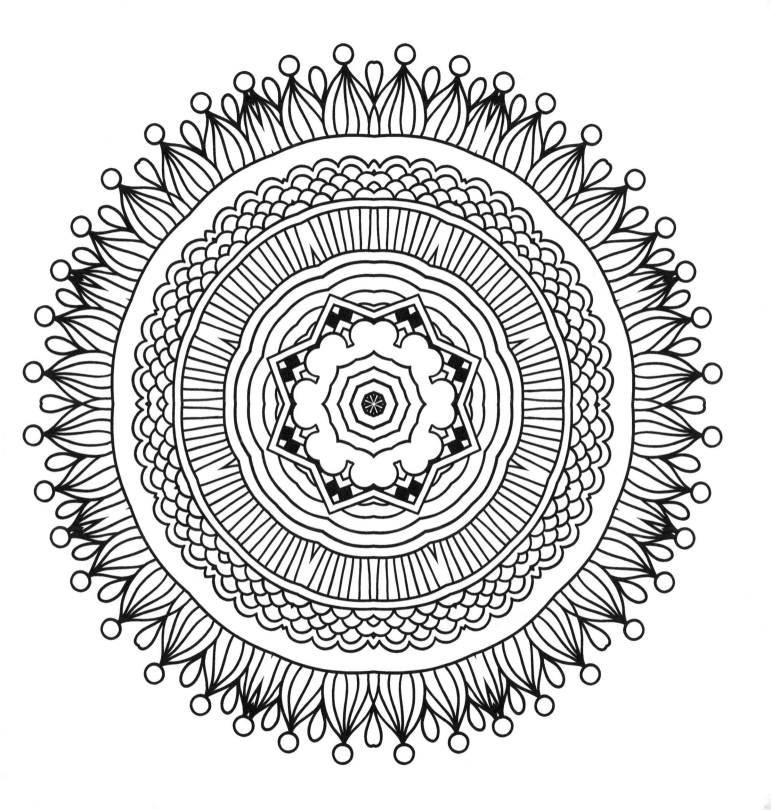

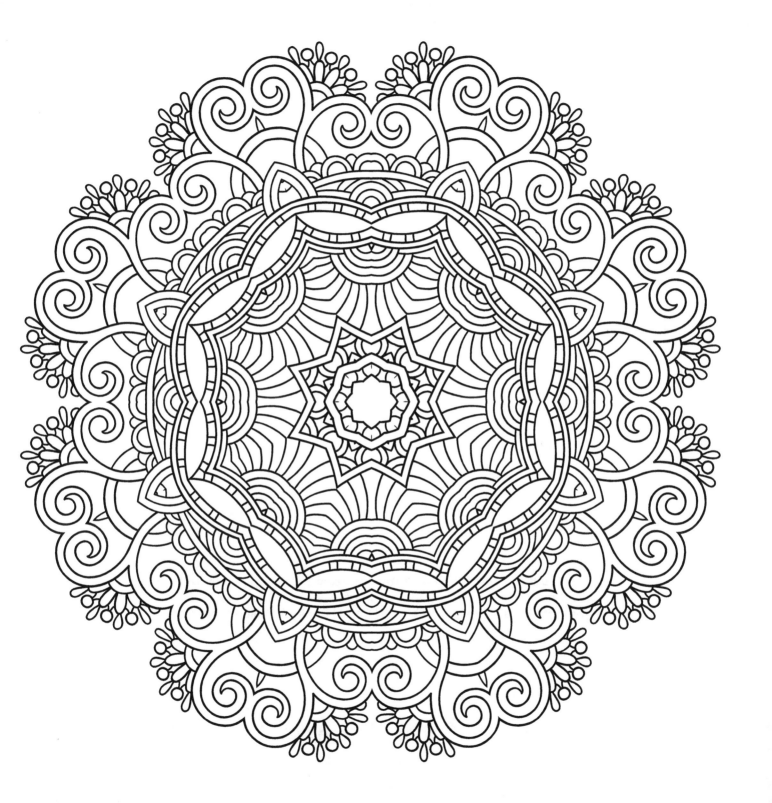

This is a Bleed Through Page If You Are Using a Coloring Marker or Pen!
Find Other Great Titles By searching for Coloring Therapists on Your Favorite Book Retailer
Amazon.Com | Barnes & Noble (BN.Com) | Books A Million (BAM.Com)

Coloring Therapists
STRESS RELIEVING COLORING ACTIVITIES

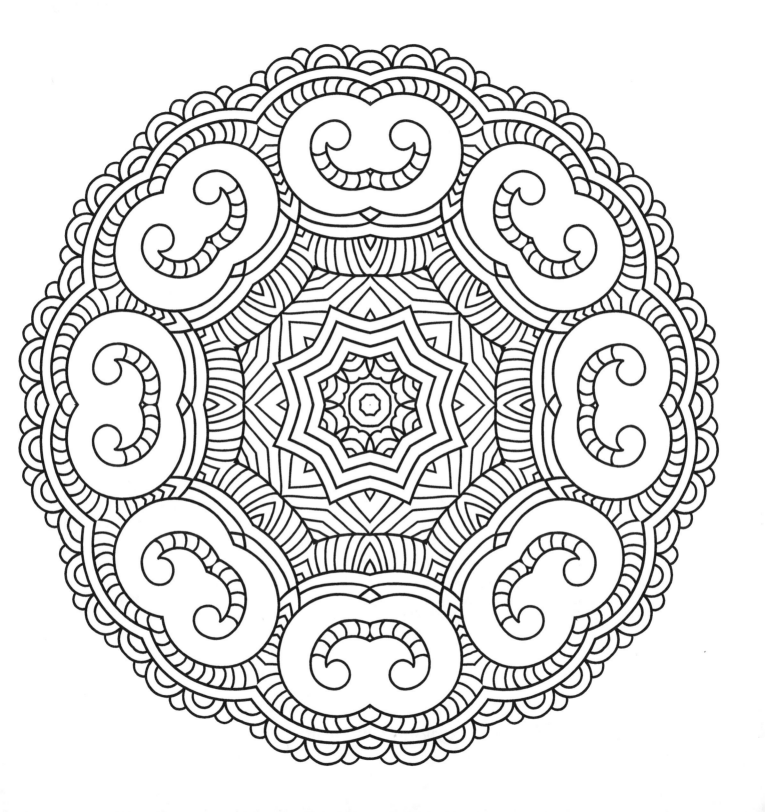

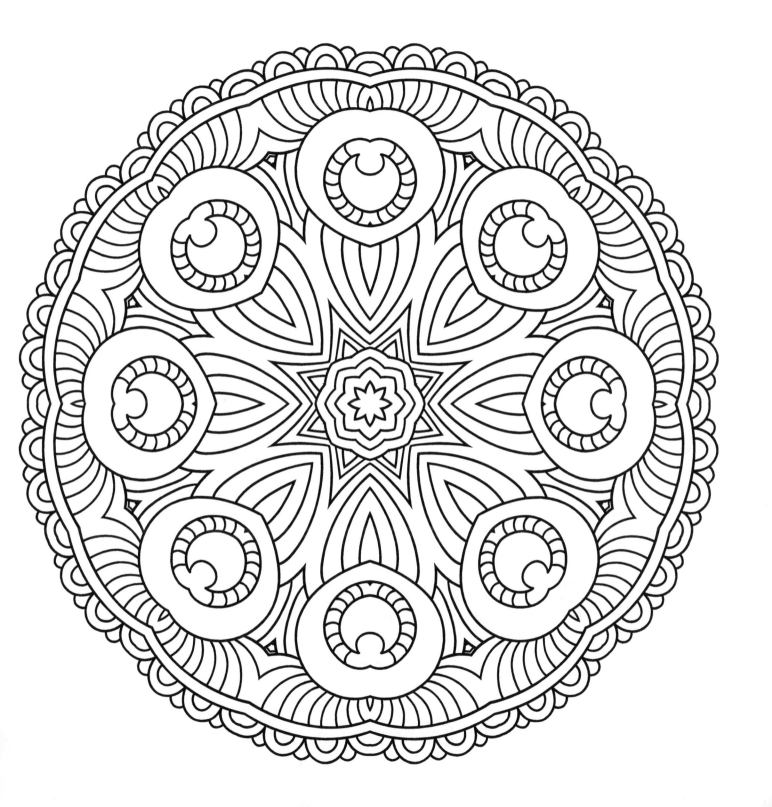

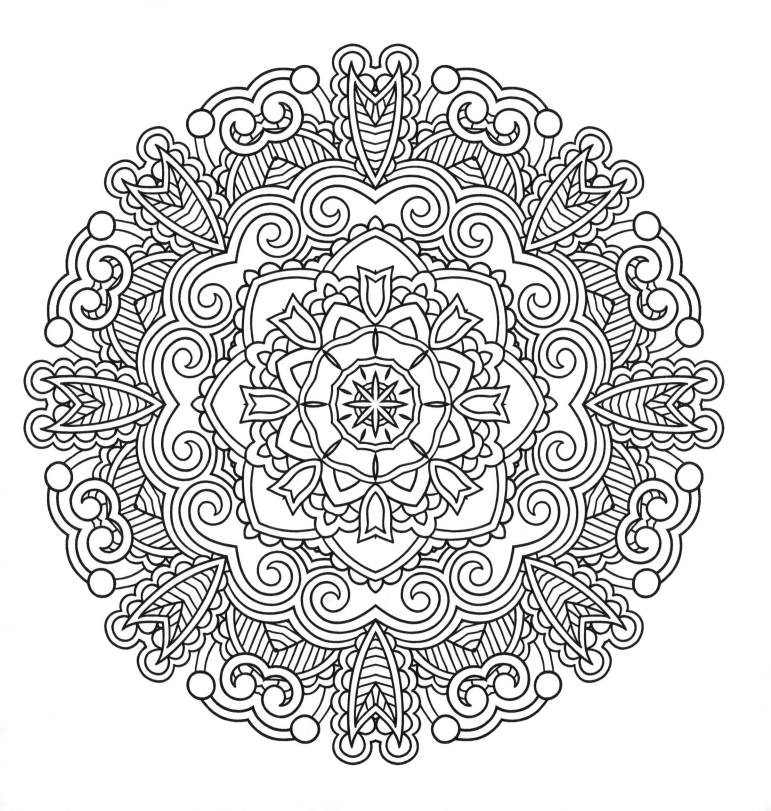

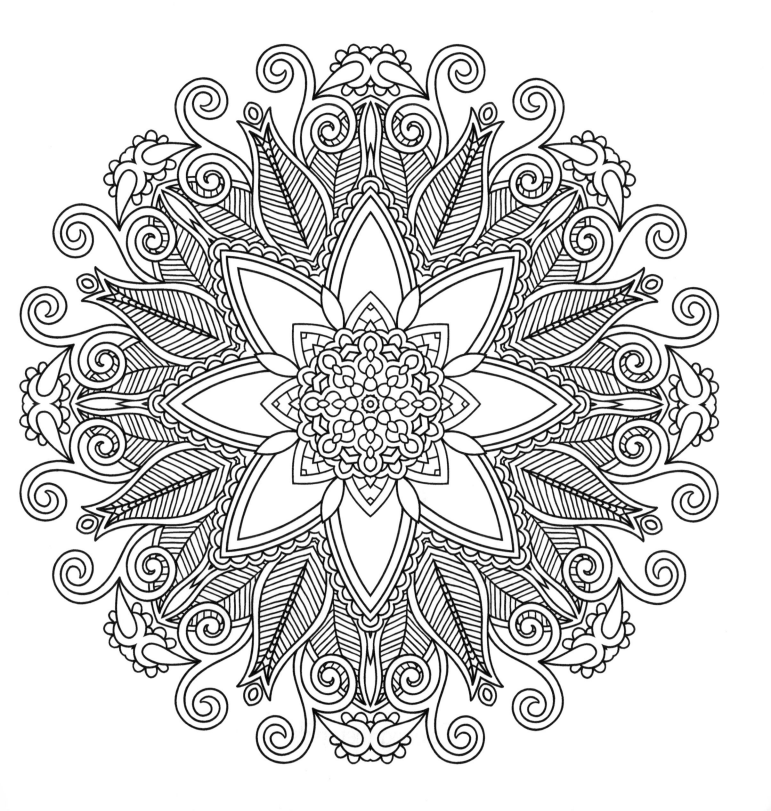

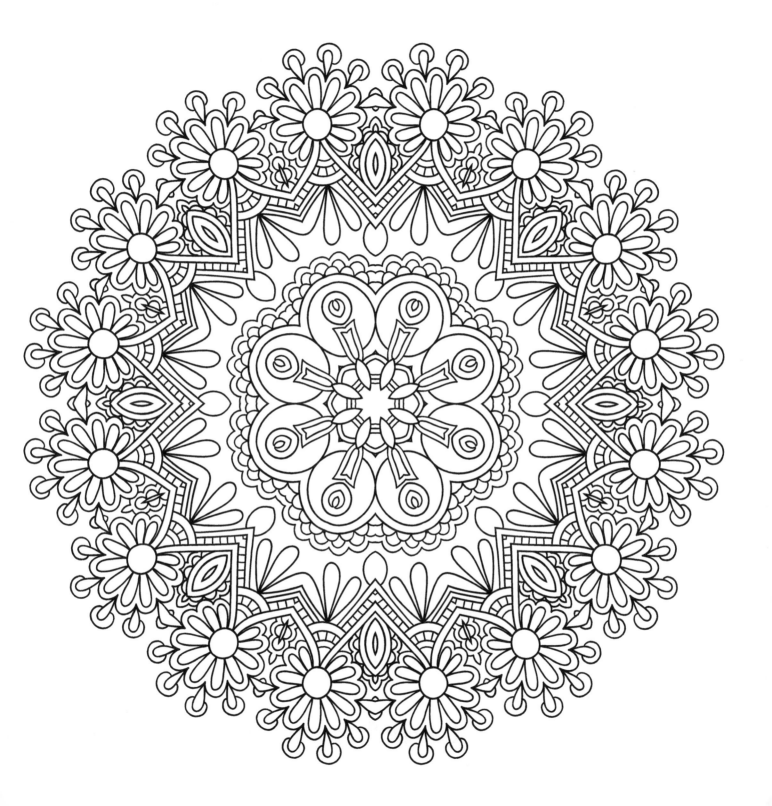

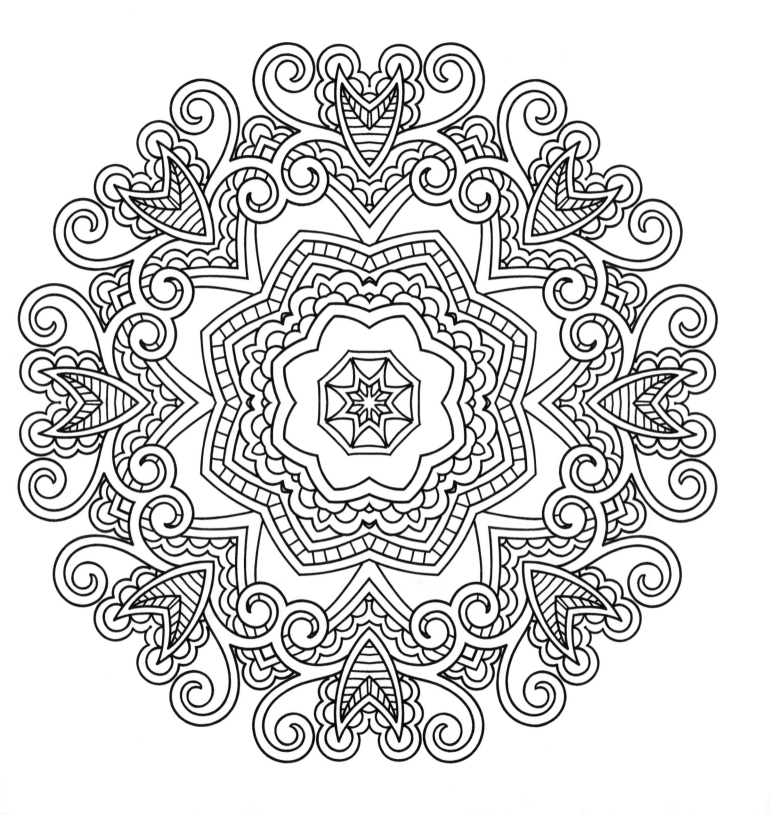

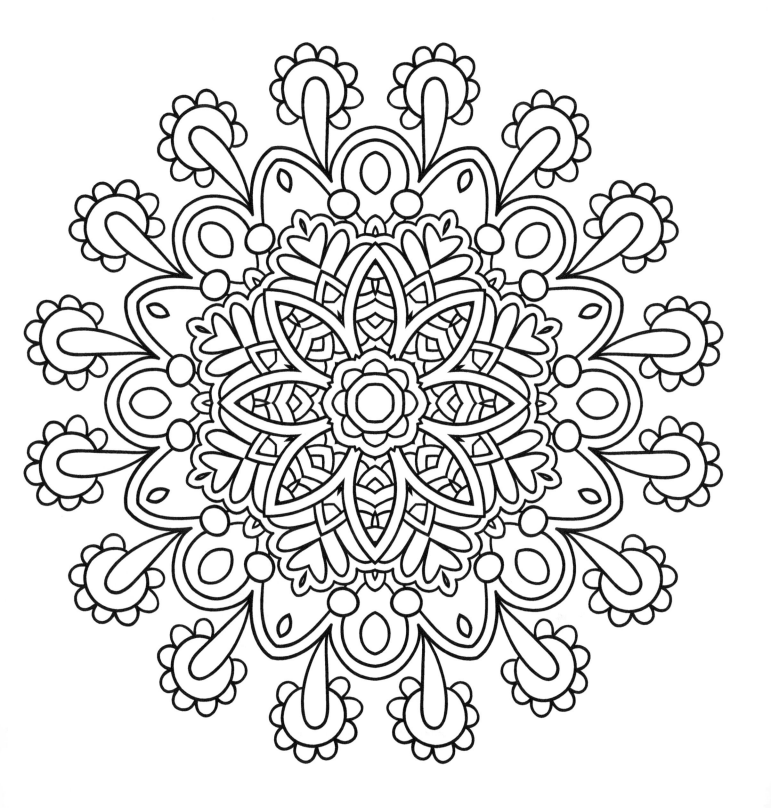

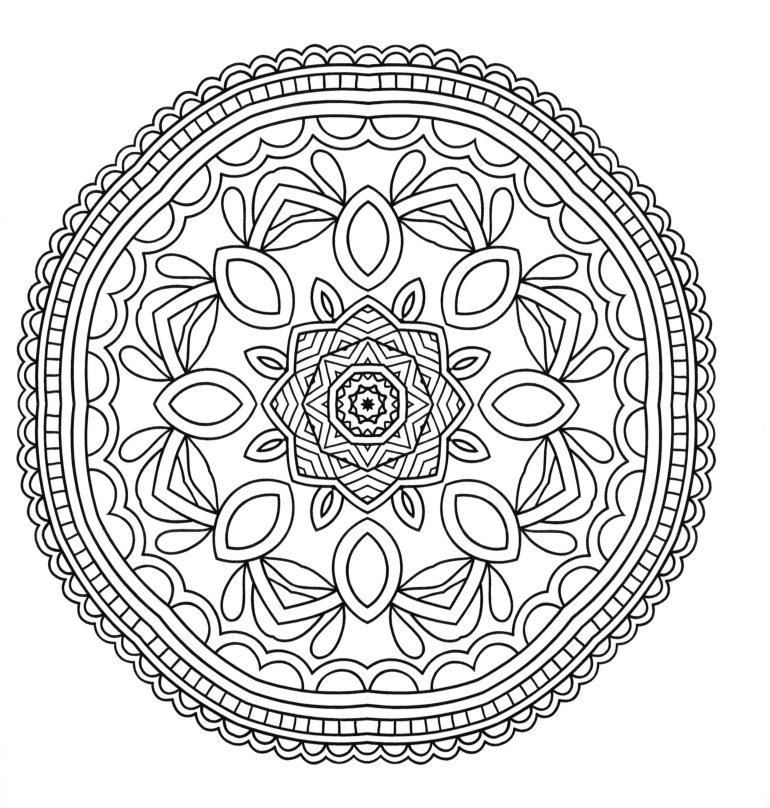

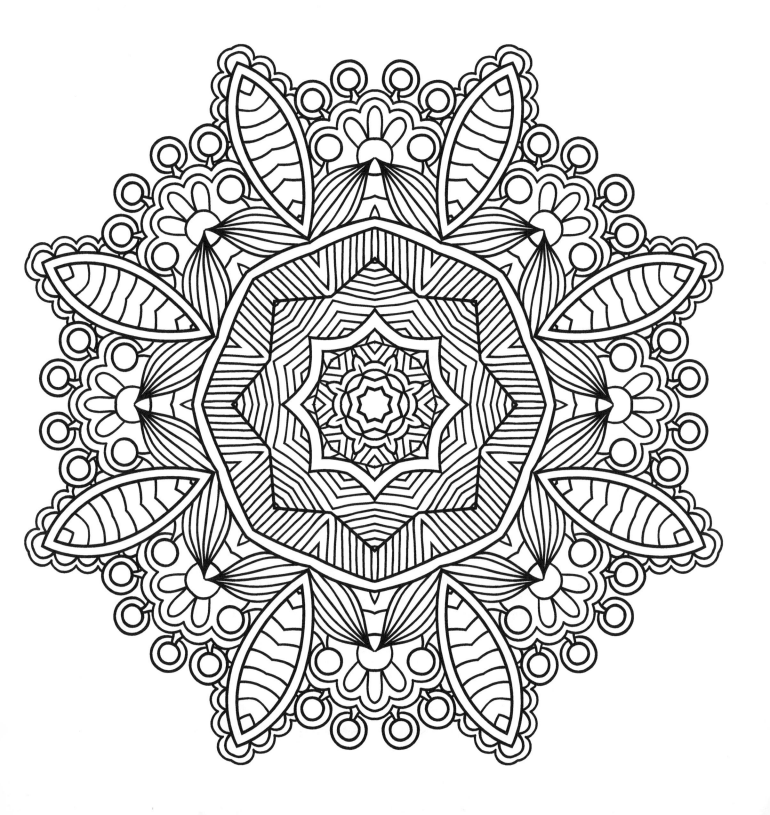

This is a Bleed Through Page If You Are Using a Coloring Marker or Pen!
Find Other Great Titles By searching for Coloring Therapists on Your Favorite Book Retailer
Amazon.Com | Barnes & Noble (BN.Com) | Books A Million (BAM.Com)

Coloring Therapists
STRESS RELIEVING COLORING ACTIVITIES

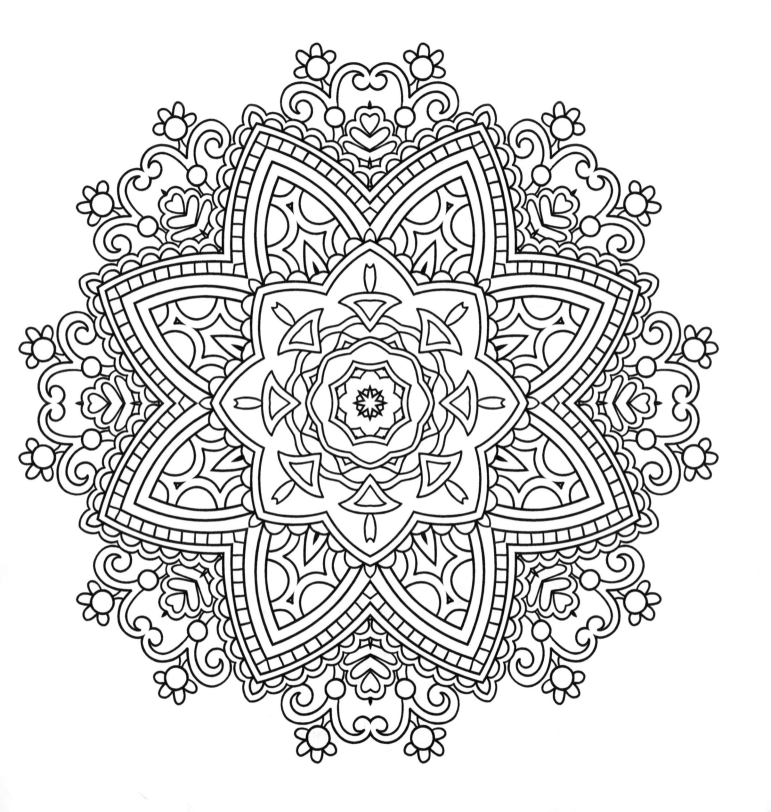

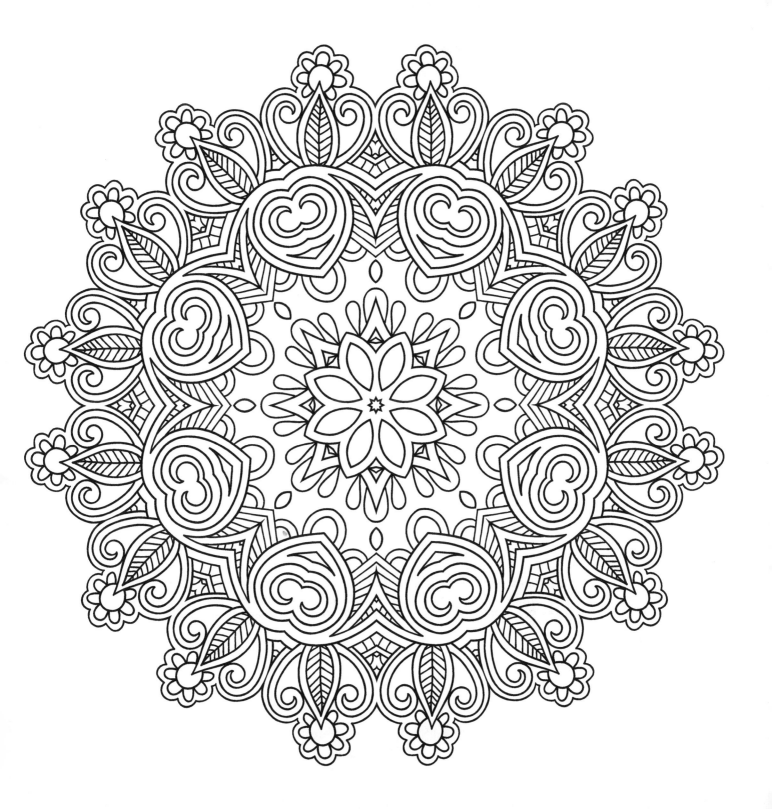

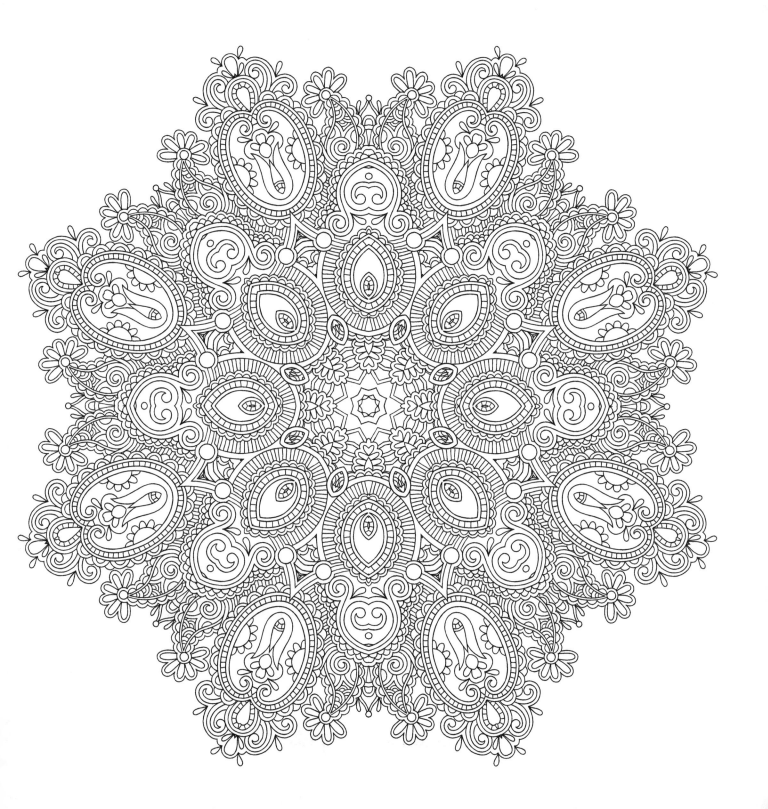

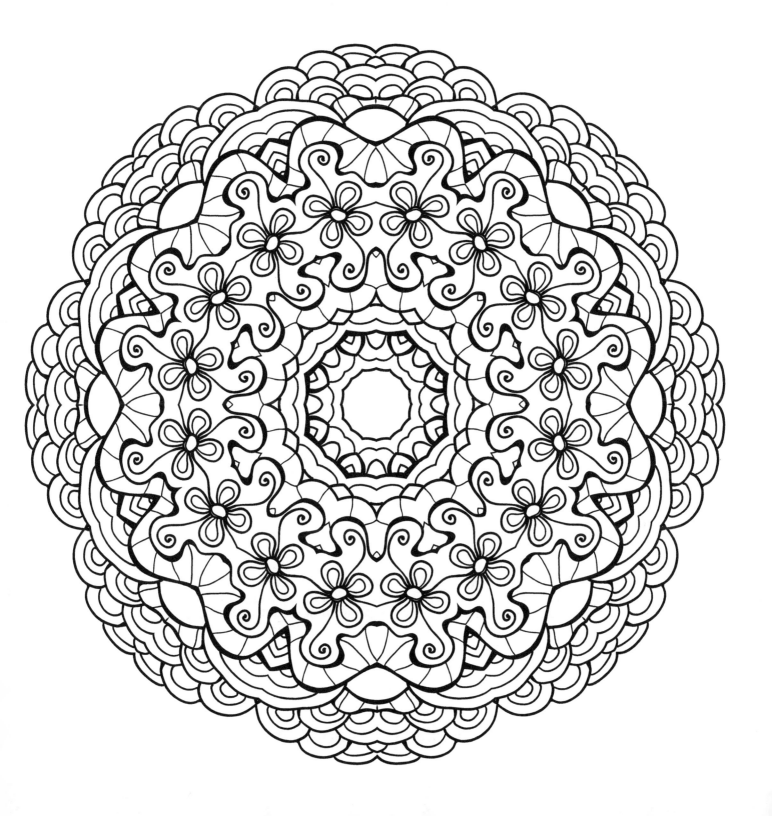

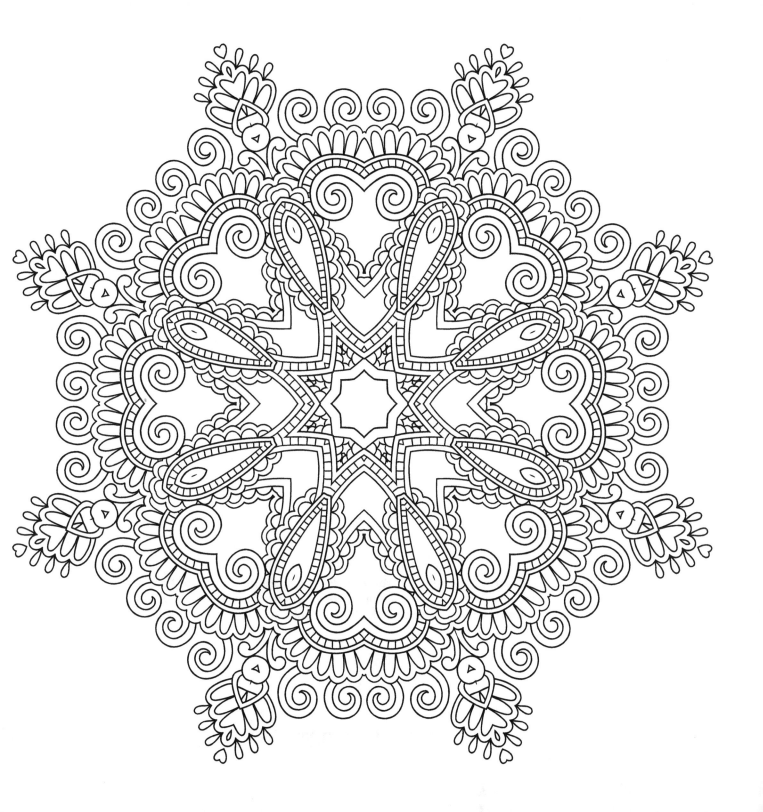

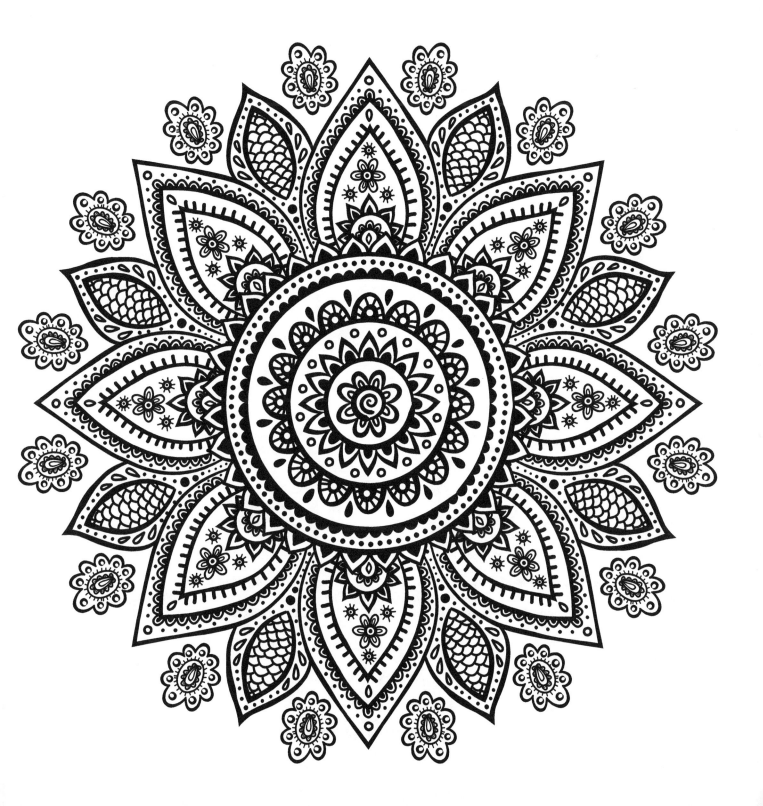

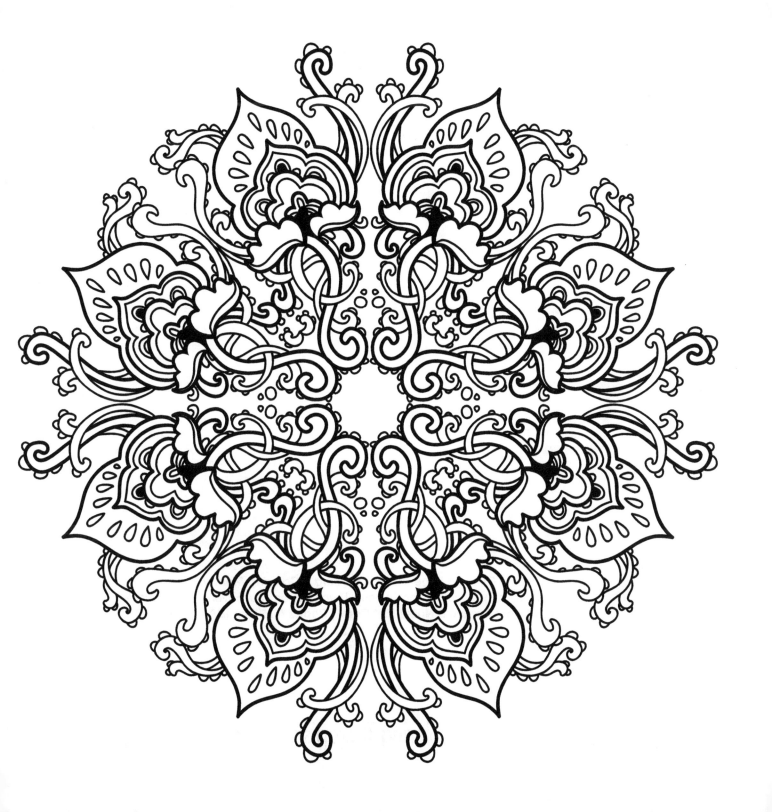

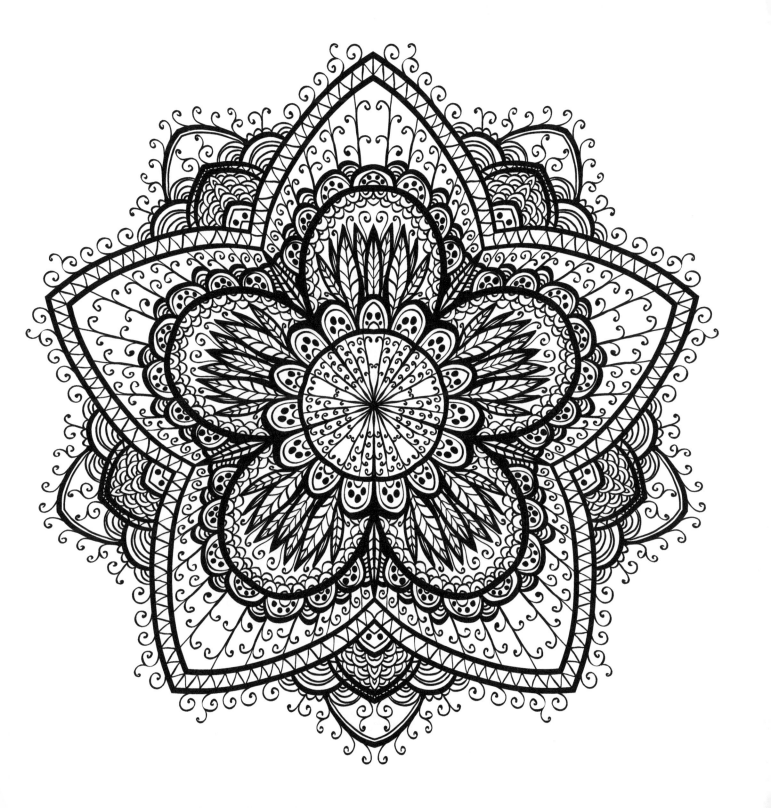

CPSIA information can be obtained
at www.ICGtesting.com
Printed in the USA
LVHW061908090920
665411LV00025B/1138